The Whitworth Art Gallery

ART SPACES

SCALA

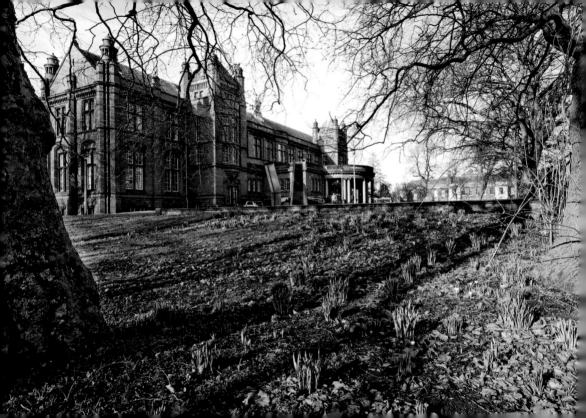

The Whitworth Art Gallery was founded more than 120 years ago, as a resource to inspire the textile industry in north-west England, as a source of pleasure and enjoyment for the citizens of Manchester and to provide opportunities for all to learn about the visual arts. It houses collections of international significance in what is a building of contrasts and surprises, a visual expression of the two principal phases of the Gallery's construction and development. The imposing Edwardian red (Welsh Ruabon) brick and terracotta façade of its first, constructional, phase (1894–1908) conceals an open-plan Scandinavian-style modernist interior characterised by a relaxed, almost 'domestic' atmosphere, created during the mid- to late 1960s. One of its most distinctive, and theatrical, spaces – a mezzanine-level Sculpture Court designed and built in the mid-1990s – is a more recent development. This literally brings the outside in, having been created by roofing over an internal well in the centre of the building and retaining its original exterior red brick wall. The Gallery's collections are similarly eclectic. They include outstanding works on paper, ranging from Renaissance prints to British landscape watercolours, the highlight of which is a group of over 50 watercolours by J.M.W. Turner, and modern and contemporary work by artists from Picasso to Lucian Freud, Francis Bacon and Tracey Emin. However, these holdings of fine art are

← Long shot of the Gallery from Whitworth Park. Photo: WG

→ The Calouste Gulbenkian Room, housing displays of modern and contemporary art from the permanent collection. Photo: KP

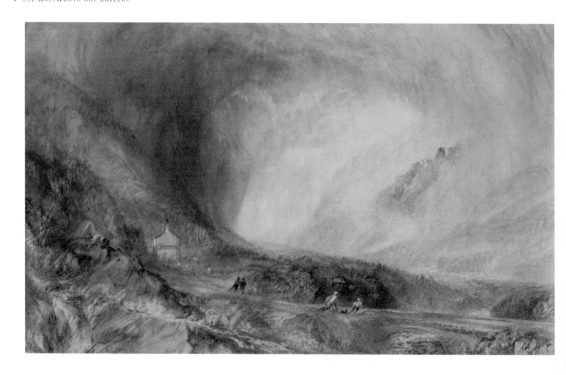

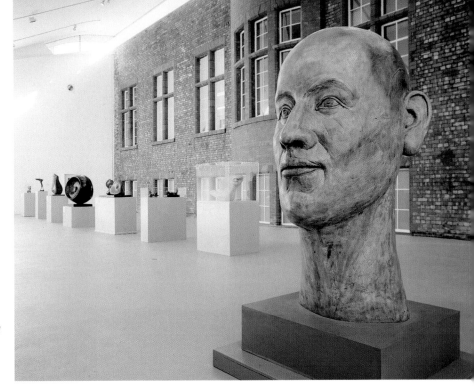

← J.M.W. Turner, **Storm in the Pass of St Gotthard, Switzerland** (1845), watercolour. This watercolour was made specially for John Ruskin.

→ The Mezzanine Court, designed by Ahrends, Burton & Koralek and opened in 1995, with John Davies, **Painted Bronze Head** (1988) in the foreground.

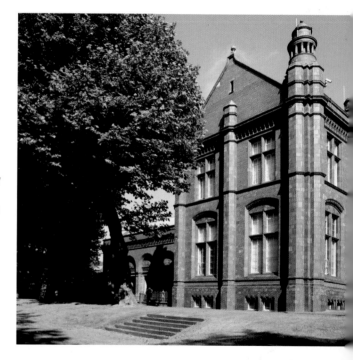

matched in terms of interest and importance by large collections of world textiles and wallpapers.

The Whitworth Art Gallery is now part of the University of Manchester and is situated at the southern end of its extensive campus to the south of the city, about 1.5 miles from the city centre. It stands in the north-east corner of Whitworth Park, which was developed along with the Gallery from former private land. The demand for public open space was high in the late nineteenth and early twentieth centuries, as there was relatively little recreational land to serve the rapidly growing working-class population of the area. Today Whitworth Park still provides a welcome green space in a densely populated urban landscape.

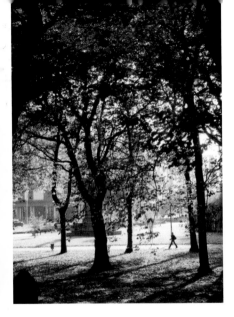

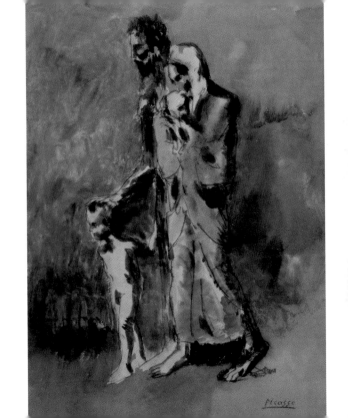

↑ *Summer in Whitworth Park, looking south. Photo: KP*

← *The south-east corner of the building.*

→ *Pablo Picasso, **Poverty** (1903), drawing, from the artist's Blue Period. © Succession Picasso/DACS, London 2010*

A MONUMENT TO MANCHESTER'S INDUSTRIAL PAST

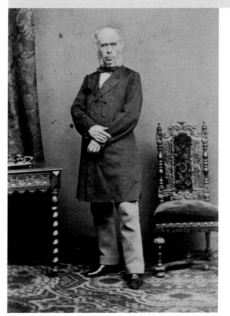

← *Detail of the façade.*

→ *Photographic portrait of Sir Joseph Whitworth by McLean & Haes (1860s), collection of the National Portrait Gallery, London. Image © National Portrait Gallery, London.*

The early history of the Whitworth Art Gallery is rooted in Manchester's industrial past and is part of the story of the city's cultural ambitions and sense of civic pride in the second half of the nineteenth century. At that period Manchester was the world's first industrial city, and its civic grandees were intent on establishing cultural institutions that would be in keeping with the city's international status and outlook. The Whitworth was one of these, and its perspective has always been international. The Gallery takes its name from an industrial magnate Sir Joseph Whitworth (1803–1887), who transformed mechanical engineering with his invention of the universal screw thread. A figure of national importance and renown at the time of his death, his name is not widely known today outside engineering history circles. Whitworth himself had little interest in art: he endowed engineering scholarships and funded many other educational initiatives, but at his death he left a considerable fortune to be used for general charitable and educational purposes,

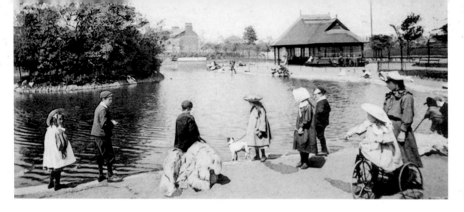

and one of his legatees, Robert Dukinfield Darbishire (1826–1908), was the driving force behind the establishment of what was originally known as the Whitworth Institute. Incorporated in 1889, initial plans for the Whitworth included not only an art museum and a park but also a museum of the industrial arts, an art school and a technical school, but all these bar the art gallery and park were soon dropped for practical and financial reasons.

The Whitworth Institute (later Art Gallery) and Park were intended as more than just an urban green space with an art gallery. They were part of a vision characteristic of the late nineteenth century that saw museums,

galleries, parks, libraries and reading-rooms as complementary instruments for forming and shaping the public's mental and physical well-being – *mens sana in corpore sano*, as the Whitworth's early benefactors might have described it. The Park was laid out in radiating avenues and provided with a bandstand and an ornamental boating lake. Both of these have long since disappeared, although there is still visual evidence of the original radiating design of walkways. A high brick wall, which had surrounded what had formerly been private, wooded grounds, was replaced by an open iron fence, and the combination of Park and Gallery proved immediately

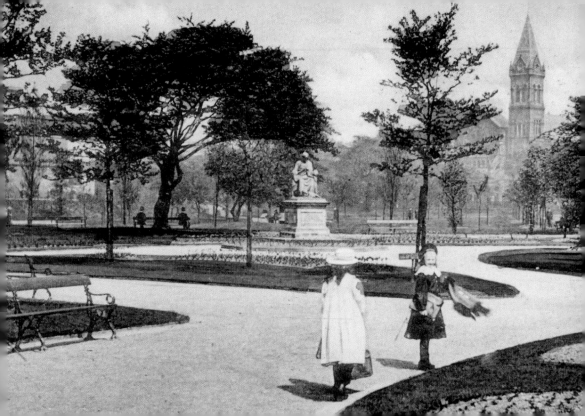

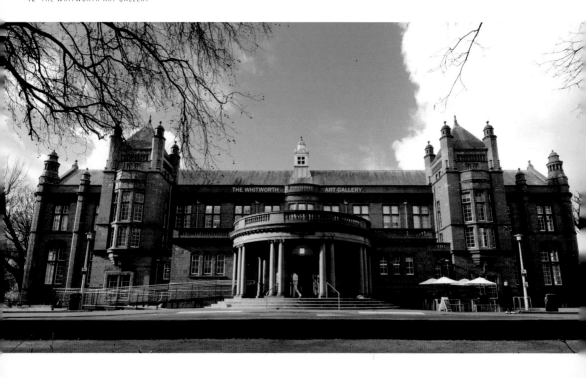

← *The Whitworth Art Gallery main façade by J.W. Beaumont & Son, essentially unchanged from the way it looked when the building first opened in 1908. Photo: JCF*

→ *Detail of the semi-circular porch. Photo: JCF*

popular with local people. Minutes of early Whitworth Committee meetings refer to concerts in the Park and comment on how widely it was used at weekends and Bank Holidays. However, the Gallery struggled, almost from the inception of the project, to cover the revenue costs associated with the maintenance of a large public park, and in 1904 the Whitworth leased it to Manchester City Council. The Council continues to manage Whitworth Park and to have responsibility for its upkeep.

The Gallery building was purpose-designed and constructed, in its original form, in three stages between 1894 and 1908. The architects were J.W. Beaumont & Son, who were selected in a competition judged by the great late Victorian architect Alfred Waterhouse, who designed both the Manchester Town Hall and the former Victoria University of Manchester. James William Beaumont (1848–1931) had his own architectural practice in Manchester from 1872 and designed a number of commercial buildings, warehouses, schools and libraries in the Greater Manchester area. The structure of the Whitworth building is symmetrical, flanked by two low towers and entered by a semicircular porch with paired grey granite columns. The apron in front

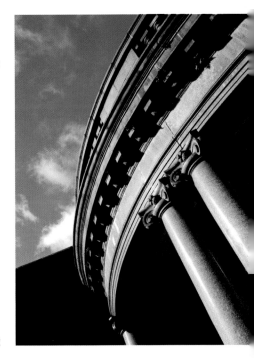

of the Gallery was laid out in terraces, with low walls topped by terracotta copings. The architectural style that Beaumont adopted for the Whitworth has been described as 'Free Jacobean', as it employs motifs derived from early seventeenth-century exemplars. Low towers, tall canted oriels and mullioned and transomed windows are combined with classical detailing. It is a style that was very popular for public and commercial buildings in the closing decades of the nineteenth century.

The exterior is executed in red brick and red terracotta, a combination seen in many public buildings of the period and widely used by Alfred Waterhouse, especially for commercial buildings. Terracotta finishes had the advantage of being easier to clean in the smoke-filled environment of an industrial city, where buildings quickly became covered with soot from the belching factory chimneys. The façades of the two large galleries to the north and south of the building have blind arcading along their sides, with large panels of decorative terracotta and acanthus inset in the tympana. These were intended to lend visual interest to the (originally) windowless brick façades.

Inside, the first gallery beyond the entrance hall was

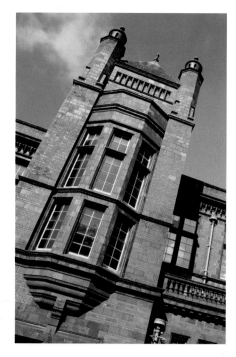

← One of the towers, with its tall, canted oriel windows.

→ Architectural detail over South Gallery windows.
Photo: JCF

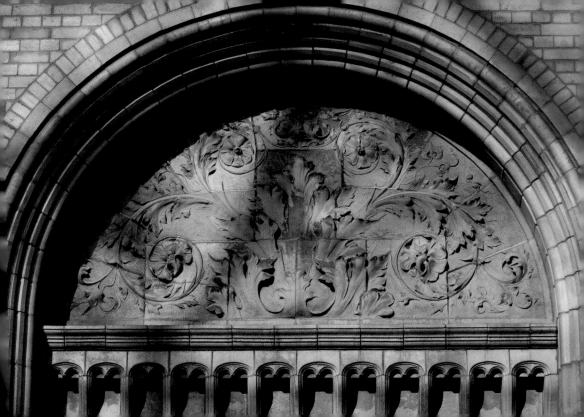

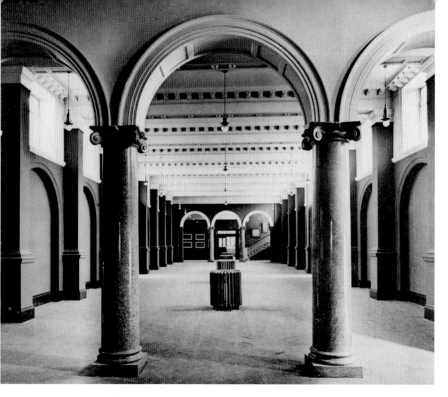

← The Darbishire Hall in 1908 with its original arcaded screen and granite columns.

→ Darbishire Hall, looking north, after the 1960s refurbishment (seen here in 2006).

named after Darbishire; since the 1930s it has housed the Gallery's textile collection, unusual for an art gallery but acknowledging the importance of textiles to Manchester's industrial wealth and supremacy. Until the 1960s Darbishire Hall was terminated at each end by an arcaded screen giving access to two sweeping grand staircases that have decorative cast-iron balustrades and

stairwells that retain their original copper and frosted-glass light fittings. Today all that remains visible inside the Gallery of Beaumont's original scheme is the entrance hall and the two staircases, and the latter are not at present open to the general public. Beaumont designed a long lecture hall to occupy the first floor space above the Darbishire Hall, with Arts and Crafts-style hammer beams supporting the roof, but this space was reconstructed in 1976 to form two Study Rooms – one for Prints and Drawings, the other for Textiles – together with a Conservation Studio and curatorial offices.

Textiles and drawings and watercolours have formed part of the Whitworth's collections since the Gallery was first established. In 1887, the year that Whitworth died and the idea of a gallery in his memory was conceived, Manchester staged a Royal Jubilee Exhibition to celebrate Queen Victoria's first 50 years on the throne. Among the machinery and industrial design at the exhibition was a section devoted to the leading practitioners of watercolour painting in England. Reviews of the exhibition praised the works on display and called for a 'representative Exhibition of English Water-colour painting from its crude beginnings … up to the present time' to be available for

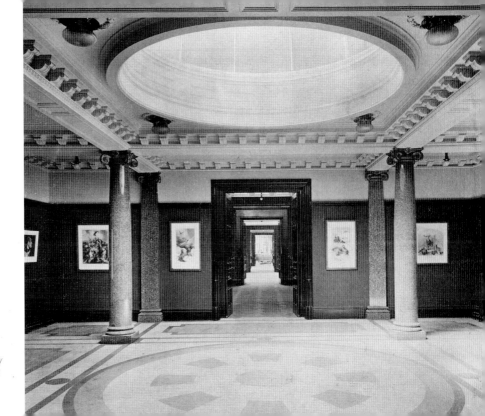

← Detail of the original
cast-iron balustrade to the
first-floor Grand Hall.
Photo: JCF

→ The entrance hall in the early
1900s, looking west to a series
of corridor galleries.

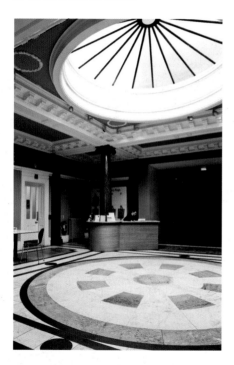

public viewing in Manchester. Accordingly, a total of 54 works were acquired for the Whitworth from the profits of the Manchester Royal Jubilee Exhibition, including a handful of works by Turner, which formed the basis of the Gallery's present collection. In 1892 the influential owner of the *Manchester Guardian* newspaper, John Edward Taylor, presented the Whitworth with an outstanding group of a further 154 watercolours from his private collection, carefully selected to illustrate the history of the watercolour tradition. Taylor's gift included some of the works for which the Whitworth is now internationally renowned. Among them were *The Ancient of Days* (*c.*1827), one of seven works by William Blake, along with 18 Turner watercolours and works by other eighteenth- and nineteenth-century masters of the watercolour medium such as John Robert Cozens and Richard Parkes Bonington.

Although the Gallery does own a small collection of historic oil paintings, the focus from the beginning was on drawings and watercolours, and in the early decades of the twentieth century photographs show the walls of the Whitworth crowded with new acquisitions, many of them donated by local collectors, who generally came from the

← *The entrance hall as it appears today. Photo: KP*

→ *The first-floor lecture hall (the Grand Hall) in 1908, with hammer beam roof.*

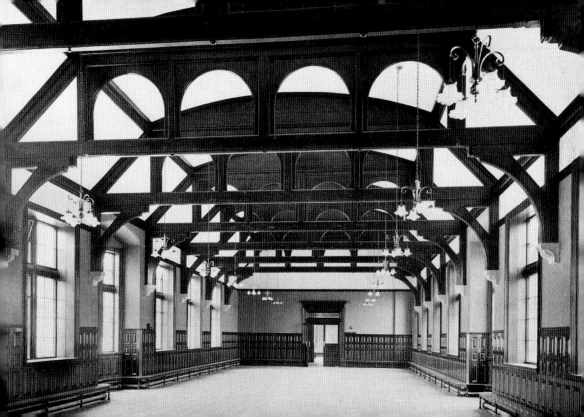

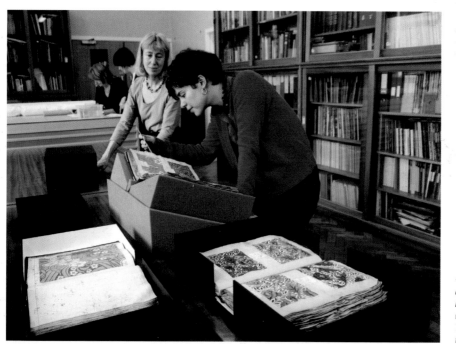

← The first-floor lecture hall was partitioned in 1976 to form Study Rooms and curatorial offices. Photo: SJ

→ J.M.W. Turner, **Moonlight over Lake Lucerne, with the Rigi in the Distance** (1841), watercolour. One of the first Turner watercolours to enter the Whitworth's collection.

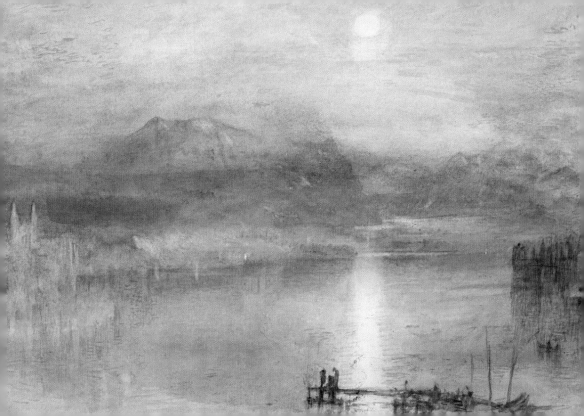

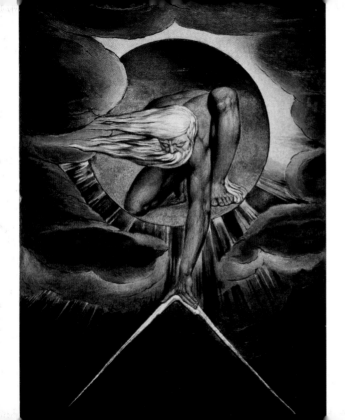

← William Blake, **The Ancient of Days** (c.1824), watercolour, ink and paint. One of the highlights of the Whitworth's watercolour collection.

→ The North Gallery in the early 1900s, with its plaster cast of the Parthenon frieze and the walls crowded with paintings, drawings and watercolours all newly acquired for the Whitworth collection.

industrial and mercantile elite of Manchester. In addition to British drawings and watercolours, the collection also includes over 300 Old Master drawings by French, Italian and Dutch artists, mainly of allegorical scenes and landscapes. The representation of landscape has been of enduring significance for British artists from the mid-eighteenth century to the present day, and the formation of a landscape tradition has always been shaped by ideas about national identity, place and belonging. As the first industrial city, Manchester has had a particularly important role to play in the articulation and visualisation of ideas about the impact of industrialisation and the growth of towns and cities, and their impact on the wider environment. Today representations of ideas about landscape continue to inform contemporary collecting of fine art at the Whitworth. Many works construct an idea of

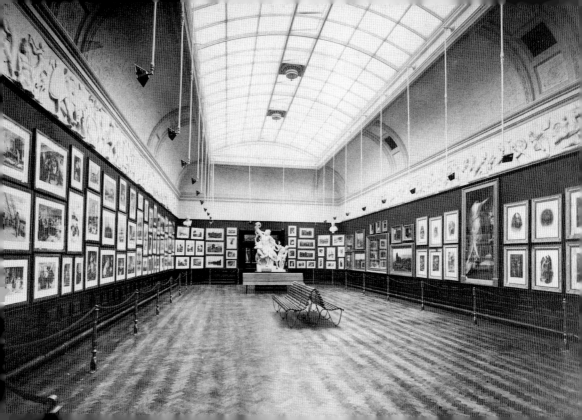

'England' that resists urbanisation, while others help to shape perceptions of the urban environment and celebrate or critique the city.

Textiles were also acquired from the Manchester Royal Jubilee Exhibition, notably three recently woven tapestries – *Flora*, *Pomona* and *Fox and Pheasants* – which were among the earliest products to come off the looms at William Morris's Merton Abbey workshops in the mid-1880s. The purchase showed great artistic prescience on the part of the Whitworth's first governors and was in keeping with their original intentions to establish a museum of the industrial arts for the city. A collection of world textiles, closely modelled on the textile collection at the South Kensington Museum (now the Victoria & Albert Museum), was quickly assembled to serve as a source of inspiration to local designers and manufacturers. The textiles that were shown at the Whitworth's opening exhibition in 1890 were lent from the private collection of Sir John Charles Robinson, an eminent Victorian collector and connoisseur who was the first Superintendent of the collections at South Kensington from 1852 to 1869. In that capacity he had travelled widely in Europe, making purchases for the South

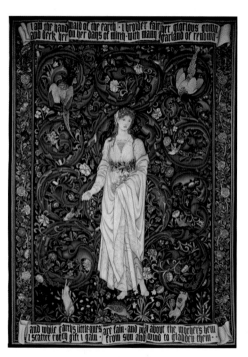

← *Morris & Company,* **Flora** *(c.1885), wool tapestry. One of the very first textiles to enter the Gallery's collection.*

→ *Hannah Smith's casket (1654–56). The earliest dated example of the embroidered boxes that were so fashionable in the second half of the seventeenth century.*

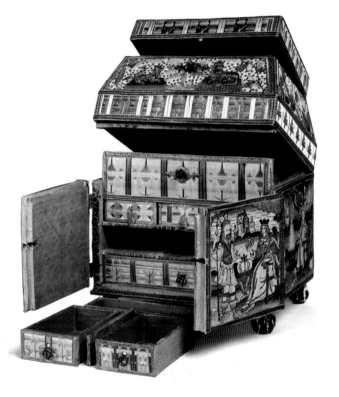

Kensington Museum and for himself, and in 1891 he sold his entire private collection of more than 1,000 textiles to the Whitworth for a nominal sum. It contained important ecclesiastical material dating from the fifteenth to the eighteenth century, European woven silks ranging in date from the late medieval period to the end of the eighteenth century, and seventeenth- and eighteenth-century English domestic embroideries.

Robinson's textile collection was augmented by his subsequent purchase, and gift, of a large group of post-Pharaonic Egyptian textiles and by other donations of textiles collected in the Indian subcontinent during the 1880s. From its beginnings the Whitworth's textile collection was never seen as just containing historical examples: contemporary work by artists and designers associated with the Arts and Crafts Movement – C.F.A. Voysey, Lewis F. Day and Walter Crane, for example, in addition to Morris & Company – was purchased regularly from the original Arts and Crafts exhibitions of the 1890s and early 1900s. Together these groups formed the foundation of the Whitworth's present-day, internationally important textile collection.

Alongside these outstanding collections of drawings

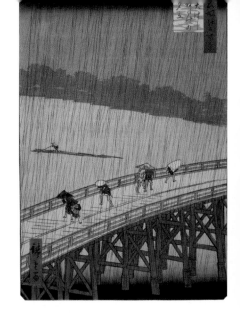

← Embroidered panel from
Egypt (late fourth century),
probably part of a group
representing The Seasons.
Embroidery was rare in
Roman Egypt.

↑ Utagawa Hiroshige,
**Sudden Shower over
O-hashi Bridge at Atake**
(1857), Ukiyo-e woodblock
print.

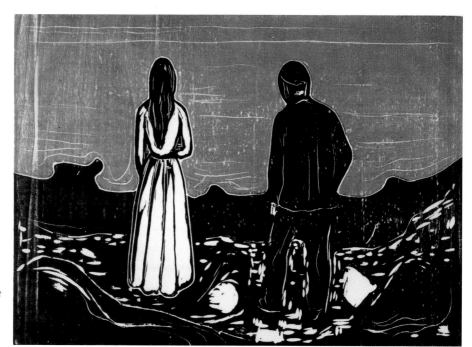

→ Edvard Munch,
Two People – The Lonely Ones (1889), woodcut.
An internationally significant gift to the print collection in 1989.
© Munch Museum/Munch - Ellingsen Group, BONO, Oslo/DACS, London 2010

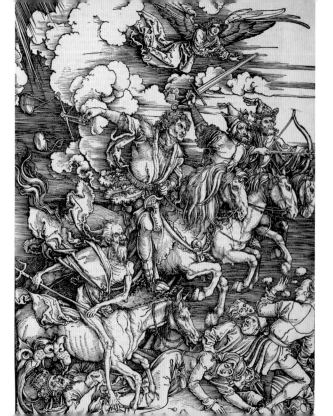

and watercolours and world textiles the Whitworth also began to develop, during the first three decades of the twentieth century, what is now the finest collection of prints in the north of England. It includes works dating from the origins of European printmaking in the fifteenth century through to contemporary work. As early as 1906 the Gallery bought a complete set of early states of Turner's *Liber Studiorum* that closely related to the watercolour collection. One of the major highlights of the print collection is a group of 70 engravings and woodcuts by Dürer, but there are also strong groups of work by the leading Netherlandish, Italian, French and Spanish printmakers, such as Rembrandt, Hollar, Mantegna, Piranesi and Goya, and one of the finest and most comprehensive collections outside London of prints by William Hogarth.

← Albrecht Dürer, **The Four Horsemen of the Apocalypse: Death, Famine, War and The Conqueror** (1498), woodcut. One of the fine continental prints in the Whitworth's extensive collection.

During the inter-war years and immediate post-war period repeated efforts were made to resolve the Whitworth's long-standing financial problems, and in consequence the building was subject to few modifications from the time of its completion until the mid-twentieth century. For over 20 years Margaret Pilkington (1891–1974), a member of the well-known philanthropic Lancashire glass family and herself an accomplished artist and wood engraver, managed the Gallery on an honorary basis with only a minimal staff. However, her personal friendships with contemporary artists and craftsmen resulted in gifts of work that continued to augment and enrich the collections. Financial salvation eventually arrived in 1958, when the Gallery and its collections were formally transferred to the University of Manchester. Margaret Pilkington endowed the University's first chair in art history, and for some 30 years the post's incumbent was also director of the Gallery. The 1960s was a period of expansion in the higher education sector, and the acquisition of the Whitworth gave the University of Manchester a resource not only to attract students and staff to the city but also to consider itself as being part of a distinctive group of world-class universities, including Oxford and Cambridge in the UK, with their own museums and galleries. It also allowed the Whitworth to begin shaping for itself a new and distinctive character as a university art gallery. Increased emphasis was placed on the Gallery's teaching function, specialist curators (initially for textiles and drawings and watercolours) were appointed and a programme of intellectually challenging but popular exhibitions was initiated.

The University quickly embarked on an ambitious programme of internal refurbishment. The work was executed within the envelope of the existing building, creating a new interior of streamlined modernity but rich in contrasting textures and materials. Doors and partition walls were removed to open up the building and new

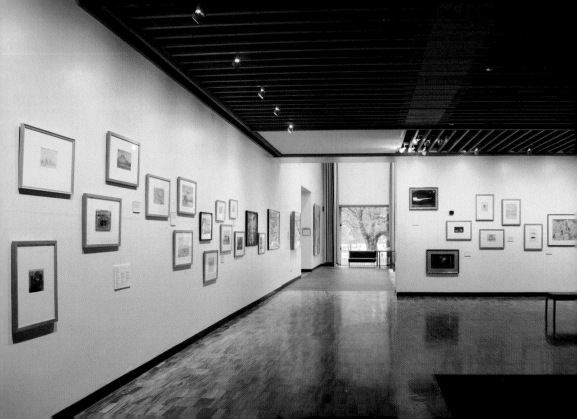

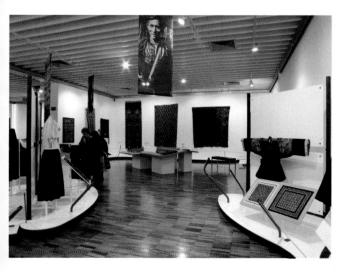

← *The Gulbenkian Room hung with modern and contemporary work from the permanent collection. Photo: SJ*

↑ *The temporary exhibition galleries hung with a loan exhibition of indigo-dyed textiles in 2007.*

galleries created for large-scale temporary exhibitions. New openings were made in existing walls that improved the relationship between the different gallery spaces. The work was carried out in two phases; the central area of the Gallery was remodelled in 1963–64 and the outer galleries in 1966–68. The design included the addition of a mezzanine floor over the North and Central Galleries to create more intimate spaces for the display of prints, drawings and watercolours, the installation of alcove cases for exhibiting the textile collection in Darbishire Hall and the conversion of an exhibition gallery at the rear of the building into a large, raked lecture theatre. Ceiling heights were lowered throughout, except in part of the North and in the South Gallery, where full-length windows were opened up to introduce daylight and provide views on to Whitworth Park. This had the effect of engaging the Gallery with the green space around it in a very direct manner and of creating a light-filled room that remains one of the most popular Whitworth spaces with those who visit.

The architect was the London-based, but Manchester-educated, John Bickerdike (1924–1981) of Bickerdike, Allen and Partners, and the hallmarks of his design were the open-plan rooms in the Scandinavian

← *The Pilkington Room hung with a display from the historic fine art collection.*
Photo: KP

→ *The Gulbenkian Room, showing a British Museum touring exhibition,* **Takhti, A modern Iranian hero**, *in 2010.*
Photo: KP

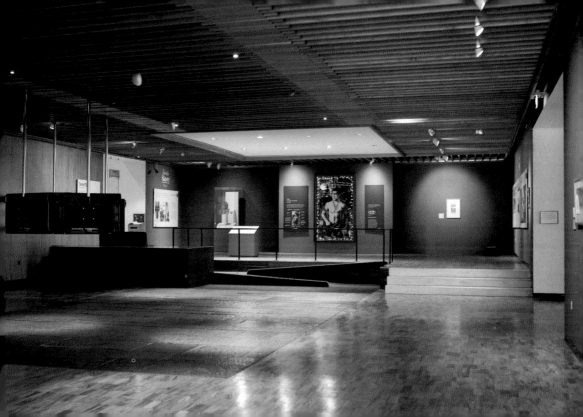

modern style and the use of a variety of natural materials and textures. Ceilings were formed from Sitka spruce slats or louvres that allowed natural light to be filtered in from the original roof lights, retained above. Some walls were clad in elm panelling, and floors were laid of loliondo (an African hardwood) blocks and natural-riven quartzite stone. Bickerdike had travelled in Scandinavia and was interested in Olof Olsson's work from 1958 at the Moderna Museet in Stockholm, perhaps partly because this too was an adaptation of a nineteenth-century building. Anecdotal evidence suggests that Louisiana, outside Copenhagen, was another influence. Certainly the latter's origins in a mid-nineteenth-century villa, the use of simple, natural materials and the engagement of the building with its surrounding parkland do seem to offer obvious parallels with the Whitworth Art Gallery.

The Bickerdike scheme was so successful that one reviewer hailed the remodelled Whitworth as 'the Tate of the North', and it is generally considered to be one of the few high-quality gallery interiors created during that period in the UK.

The 1960s' modernisation provided the stimulus for an expansion of the exhibitions programme and, even

↑ *The South Gallery, looking out to Whitworth Park.*
Photo: KP

→ *The temporary exhibition galleries.*

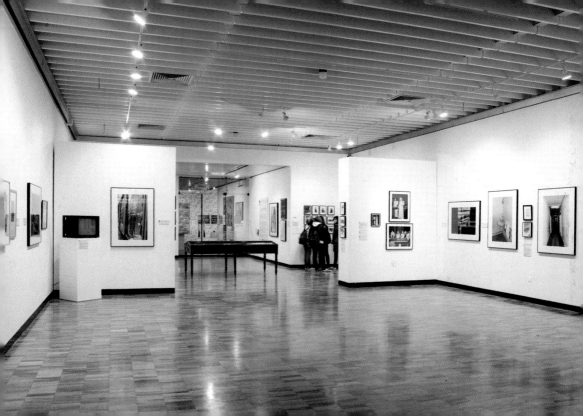

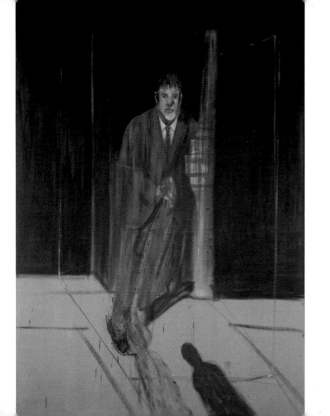

more notably, the development of the collections.
Although important modern and contemporary works by
British and Continental European artists were added to
the fine art holdings throughout the first half of the
twentieth century, the 1960s, '70s and '80s witnessed
a period of unparalleled contemporary collecting. The
excitement and ambition of the time are reflected in
the high standard of the works that were acquired, which
include major pieces by Francis Bacon, Lucian Freud,
Gilbert and George, and Howard Hodgkin. The '60s are
particularly well represented, with an emphasis on the
contribution made by British artists to the international art
scene during the period of Pop Art. The Whitworth's new,
determinedly contemporary, interior was designed to
enhance the display of oils, drawings and prints by
leading artists of the day, and key works by David
Hockney, Bridget Riley, Eduardo Paolozzi, Peter Blake and
Richard Hamilton were all acquired during this period.

The modern and contemporary fine art collections
today encompass oil painting, sculpture, photography
and video, although work on paper remains the central
material focus. Recent acquisitions of prints and drawings
by artists such as Tracey Emin, Rachel Whiteread and

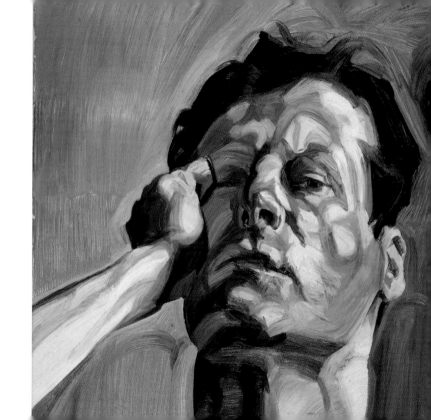

← *Francis Bacon,* **Portrait of Lucian Freud** *(1951), oil on canvas. The first of a series of portraits of Bacon's friend and fellow artist and a major acquisition for the collection of modern art.*

→ *Lucian Freud,* **Man's Head (Self Portrait)** *(1973), oil on canvas. One of Freud's many self-portraits.*

Ilana Halperin continue this emphasis, while video works by Willie Doherty, Jane and Louise Wilson, Michael Landy and Nick Crowe all have content that chimes with the themes of landscape and identity. Works from the historical and modern periods can thus engage in lively visual dialogues around space and place, and the meanings that they generate. This specialism makes the Whitworth one of the most important galleries in the UK for the study of the rural and urban landscape and has contributed to shaping plans for the future development of the building.

The Whitworth also led the way in the early 1960s in beginning to build systematically a collection of twentieth-century textiles, which now includes work by all the leading manufacturers and retailers of the post-war period. Of particular interest is an extensive group of textiles designed by artists, which includes work by Paul Nash, Henry Moore and Ben Nicholson. More recently, the collection of modern and contemporary industrial textiles has been joined by a growing body of one-off art textiles. These different groups of textiles made or designed by artists forge interesting links with both the Gallery's fine art collections and the historical world textiles.

← *Peter Blake,* **Got a Girl** *(1960–61), enamel, photo collage and record. In collecting work from the 1960s, there was an emphasis on the British contribution to Pop Art.*

↑ *Tracey Emin,* **Home to Sleep** *(2007), ink monotype. A recent acquisition for the contemporary collection by a leading British artist.*

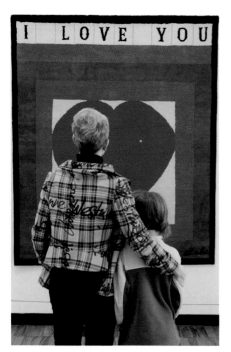

The period of collections expansion in the '60s was further enhanced by the acquisition of a 'wallpaper museum', presented to the Whitworth in 1967 by the Wall Paper Manufacturers Limited. It marked the beginning of a new phase in the development of the Gallery's collections. The mechanisation of the wallpaper industry was pioneered in England's north-west, and many of the industry's leading manufacturers were located in the region. The Wall Paper Manufacturers Limited controlled some 98% of the wallpaper industry from 1899 to the mid-1960s and wished to see, in the public realm, a record of industrial achievement in the sector. Specialist collections of wallpaper are comparatively rare worldwide, and the Whitworth now holds the most comprehensive and significant collection outside London, ranking with major collections in France, Germany and the United States. It is a very wide-ranging collection, including examples of hand-printed decorations intended for elite markets from the seventeenth century onwards, avant-garde products by named designers such as William Morris and Walter Crane, and examples of industrial production for mass-market consumption. The collection is predominantly British but also includes important

← *Peter Blake,* ***I Love You***
(1982), wool carpet. From a limited edition series hand-knotted in India to designs by artists.
Photo: JCF

→ *Alice Kettle,* ***Three Caryatids***
(1988–89), machine embroidery. A major work by one of Britain's foremost textile artists.

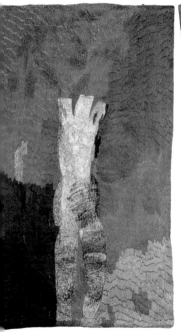
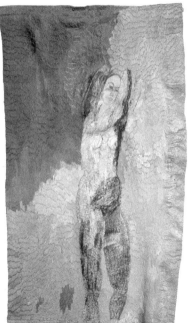
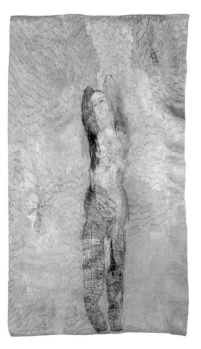

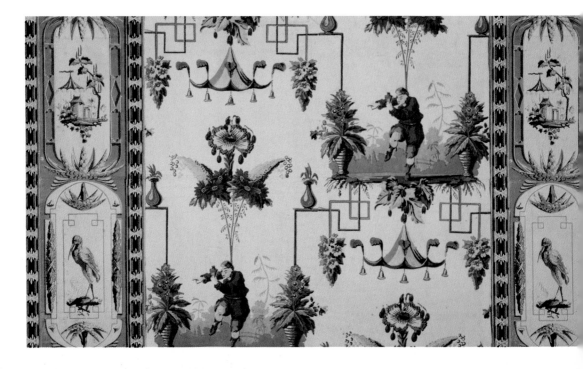

← Studio of Jean-Baptiste Reveillon, hand block-printed wallpaper (c.1789). A wallpaper in the pseudo-Chinese style that provided a cheaper alternative to Chinese hand-painted decorations.

French wall coverings such as *arabesque* panels, *trompe-l'oeil* draperies and scenic *tableaux* by leading manufacturers such as Dufour et Cie and Zuber, reflecting the historical importance of French design. As with textiles, the Whitworth has also developed a collection specialism in wallpapers designed by modern and contemporary artists that further cements the relationship of the wallpapers to the fine art and textile collections. These kind of disciplinary juxtapositions exemplify the Whitworth's approach to building and interpreting its collections.

The collections lie at the nexus of the present-day Whitworth as both creative 'laboratory' and research resource. The Gallery is at the forefront of work that uses collections in new ways to engage and stimulate visitors – both new ones and old friends – and, importantly for Manchester, has come to be recognised nationally and internationally for its provocative and playful exhibitions programme. Changing thematic displays from across the collections also assist with extending and diversifying the Gallery's audiences. Building significant holdings of contemporary work across the various collection disciplines and exploring innovative ways to access and

→ Francesco Simeti, **Arabian Nights** (2003), digitally printed wallpaper. An artist-designed wallpaper based on a pattern from 1789 by Jean-Baptiste Reveillon.

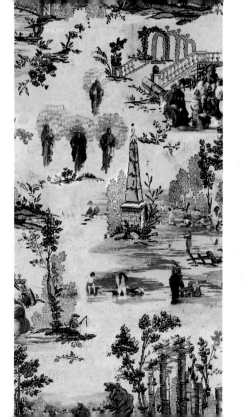

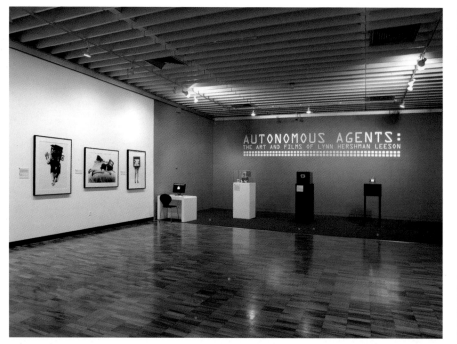

← *The temporary exhibition galleries hung with* **Autonomous Agents**, *a retrospective of the work of Lynn Hershman Leeson, in 2007.*

→ *A wallpaper installation by Erwan Venn in the exhibition* **Walls Are Talking**, *2010, looking through to wallpapers designed by Deborah Bowness.*
Photo: KP

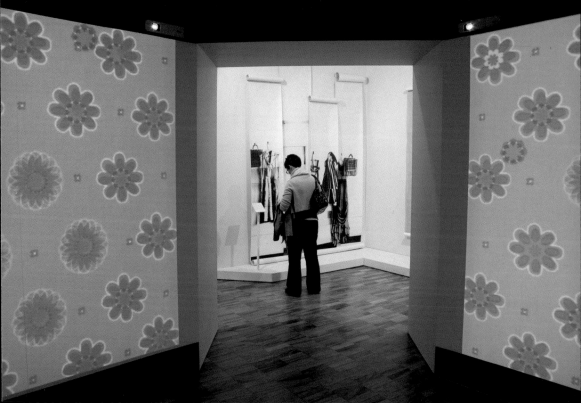

It is a common error to suppose that art is a luxury. In the best sense of the word it is a necessity.

Charles Rowley, c.1884

← The Central Mezzanine hung with an exhibition from the Walter Crane Archive, acquired by the University of Manchester in 2002. The archive represents the most important collection of material relating to Walter Crane and is split between the Whitworth and the John Rylands Library.
Photo: KP

→ The Mezzanine Court hung with work from a touring exhibition of international textile art, **Cloth and Culture Now**, shown at the Whitworth in 2008.
Photo: KP

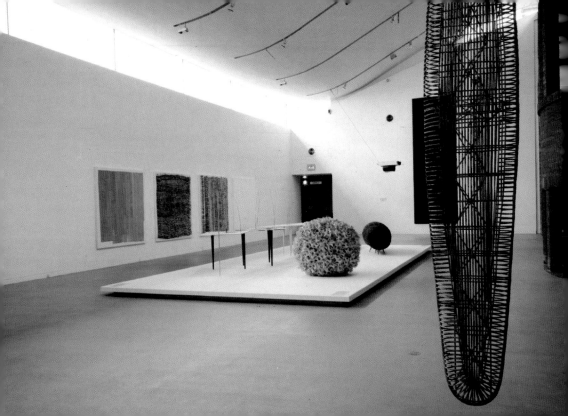

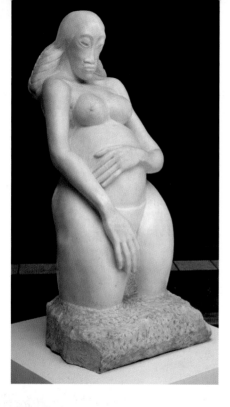

interpret them, the Whitworth has become a significant player within the contemporary art field.

In 1989 the Whitworth celebrated its centenary by launching a fund-raising campaign to extend further the space available for the display of its ever-growing collections. A new public gallery, the Mezzanine Court, designed by London-based architects Ahrends, Burton & Koralek, was opened in 1995 to much acclaim. In addition to the theatricality of its inside/outside quality, created by the retention of an original exterior red brick wall, its most eye-catching feature is a wave-like angled roof that appears to float above the space. The creation of the Mezzanine Court provided an ideal space for the display of the modern and contemporary sculpture collection, which has its genesis in the 1950s and includes work by Henry Moore, Barbara Hepworth, Eduardo Paolozzi and Anthony Caro, but on occasion large-scale art textiles have also been displayed there to stunning effect.

← *Jacob Epstein,* **Genesis** *(1929–31), seravezza marble. Once ridiculed, Genesis is now regarded as one of Epstein's greatest works.* © The estate of Sir Jacob Epstein

→ *A textile installation,* **Shindigo Space 07**, *by Japanese artist Hiroyuki Shindo on display in the Mezzanine Court.* Photo: JCF

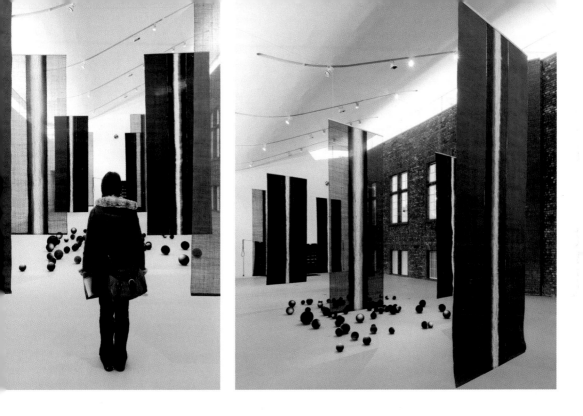

Today J.W. Beaumont & Son's original Whitworth building is over 100 years old, and the Gallery's stores and public spaces are stretched to the very limit. Recent years have seen a huge expansion of the public programmes and a significant growth in both local visitors and tourists to Manchester and the region. The appointment of a new, young director – Maria Balshaw – in 2006 provided the impetus for staff and stakeholders in the Whitworth to develop a vision for the Gallery that would redefine its role for the twenty-first century. Following an international competition in 2009, the University of Manchester appointed the London-based (but Scottish-educated) architectural practice MUMA to help the Gallery realise this future vision.

At the heart of the project is an extension to the current building that physically and visually reconnects the Gallery with Whitworth Park and which will thereby re-establish its relationship with the many local community

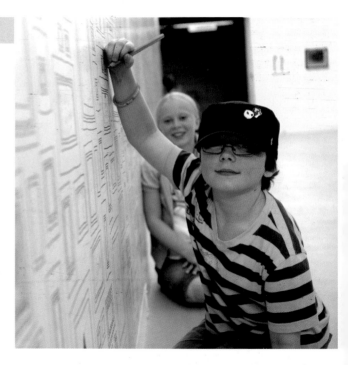

← A wallpaper-based workshop for younger visitors.
Photo: JCF

→ A guided tour of the galleries, led by the director, Maria Balshaw.
Photo: JCF

↘ MUMA's model study of the south elevation to the remodelled Gallery.
© MUMA

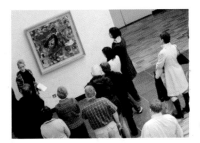

users of the surrounding green spaces. It is a piece of new build designed with great sensitivity to both the existing building and the mature park setting. Two new wings at the rear of the building will create a central garden court that will bring new life to the west end of the Gallery, and these wings are linked by a glazed Promenade Gallery that provides sweeping views over the parkland. One of the new wings will house a landscape gallery reaching out into the park and, beneath it, a study

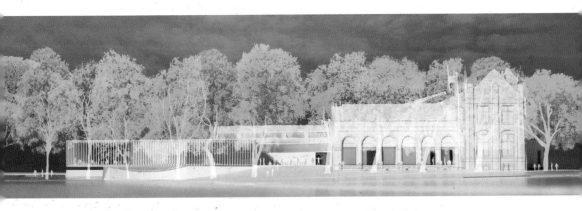

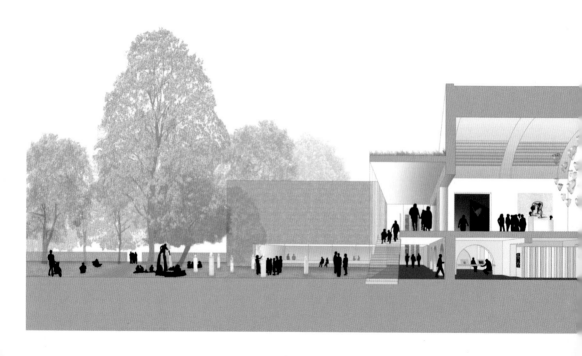

centre where the stored collections can be seen and used by all visitors. The other wing forms dedicated spaces for creative workshops and a light-filled café, elevated to the level of the tree canopy, that appears to 'float' in the branches of the surrounding ash and plane trees and creates a striking relationship between the built and the natural environment.

At the same time there are plans to transform the environment outside the Gallery by commissioning artists to create an external landscape for rest, relaxation and play, and encouraging visitors to see the outdoors as a social space linking the building and the park. There will also be some remodelling of the existing spaces: the room available for temporary exhibitions will be extended to allow bigger, more internationally ambitious shows to be brought to Manchester or to be created from the Gallery's own collections; a new grand hall for lectures, films and social events will be recovered at first-floor level, above the Textile Gallery, its oak hammer beams and wood wall panelling restored; and the two grand staircases will be opened up to the public again.

Working with MUMA, the Whitworth director and her staff intend to create a suite of beautiful spaces where visitors can enjoy and learn from thought-provoking juxtapositions of contemporary and historical art and design, a lively social hub for the university and its neighbours, and a place for contemplation in a green oasis in the urban landscape south of the city.

← *Part section of the remodelled Gallery seen through the proposed Art Garden. A new Promenade Gallery connects the temporary exhibition galleries to the garden.*
© *MUMA*

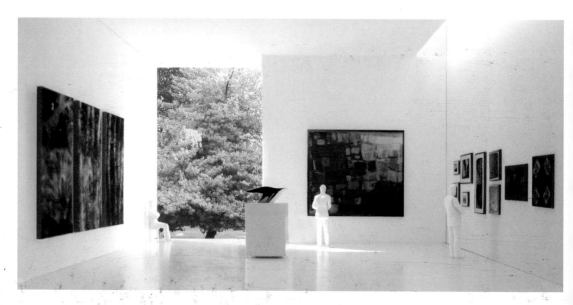

↑ Model study of
the proposed
Landscape Gallery.
© MUMA

→ Model study of the
Landscape Gallery with image
of sculpture by Anya Gallacio.
© MUMA

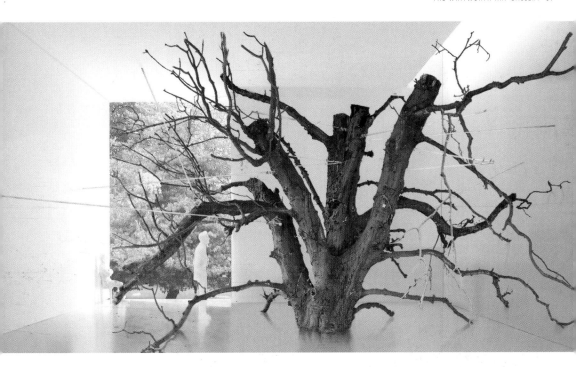

↓ *The remodelled temporary exhibitions galleries, with works by Christine Borland. © MUMA*

↓ *Their original ceilings are recovered to create a greater volume of space. © MUMA*

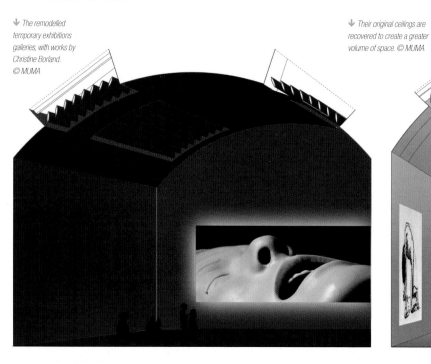

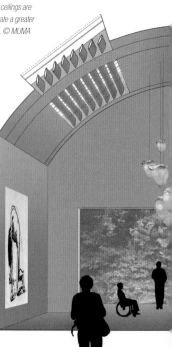

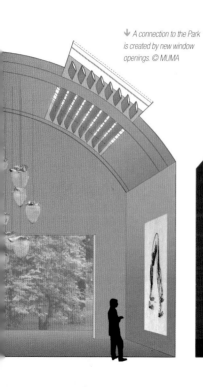

↓ A connection to the Park is created by new window openings. © MUMA

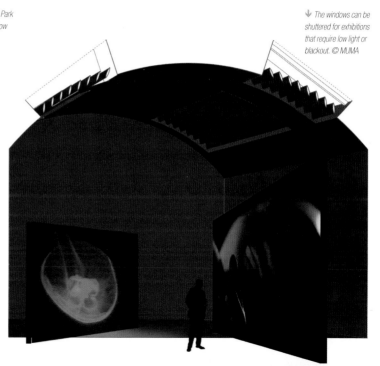

↓ The windows can be shuttered for exhibitions that require low light or blackout. © MUMA

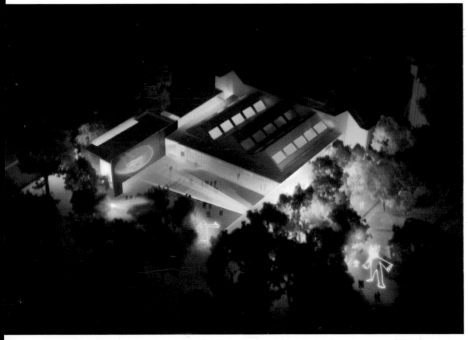

← Aerial view of the extended Gallery at night, with an exterior projection. © MUMA

→ Work by Michael Brennand-Wood displayed in the touring exhibition **Cloth and Culture Now**, shown at the Whitworth in 2008.
Photo: JCF

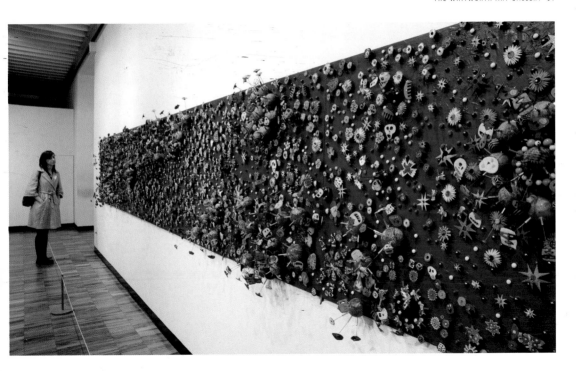

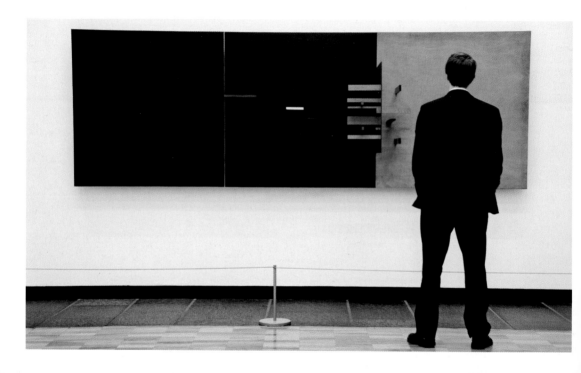

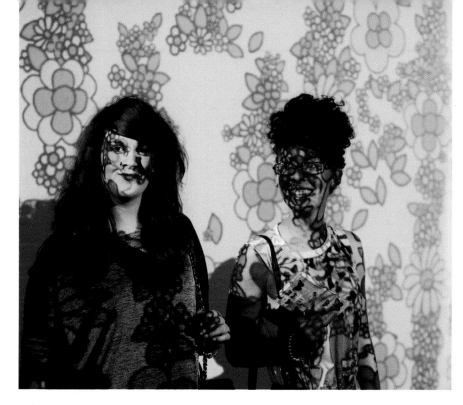

← Visitor engaging with Victor Pasmore's **Architectural Relief Construction** (1965), wood, paint and perspex. This work was given to the Gallery in 1977 by the artist, who had links with the University.
Photo: JCF

→ Visitors engaging with a wallpaper installation by Erwan Venn in the exhibition **Walls Are Talking**, shown in 2010.
Photo: Tape

© Scala Publishers Ltd
Text and photography
© Whitworth Art Gallery, 2011

First published in 2011 by
Scala Publishers Ltd
Northburgh House
10 Northburgh Street
London EC1V 0AT, UK
Telephone: +44 (0) 20 7490 9900
www.scalapublishers.com

ISBN: 978 1 85759 585 7

Photography: Joel Chester Fildes (JCF),
Sarah Jones (SJ), Katia Porter (KP) and
Warren Grime (WG)
Project editor: Esme West
Designer: Nigel Soper

Printed and bound in Hong Kong

10 9 8 7 6 5 4 3 2 1

British Library Cataloguing in
Publication Data
A catalogue record for this book is
available from the British Library

Front cover: *Exterior of the building from the
south east, with sculpture by Michael Lyons,*
Phalanx *(1977), painted steel, in the foreground.*

Back cover: *Andy Warhol's 'Mao' wallpaper
(designed1974) on display in the exhibition
'Walls Are Talking', 2010
Photo: Tape*

→ *Photo: JCF*

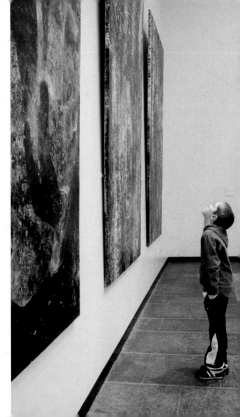